Borders for Calligraphy

OTHER BOOKS BY MARGARET SHEPHERD FROM MACMILLAN

Learning Calligraphy
A Book of Lettering, Design, and History

Using Calligraphy
A Workbook of Alphabets, Projects, and Techniques

Capitals for Calligraphy
A Sourcebook of Decorative Letters

ALSO BY MARGARET SHEPHERD

Calligraphy Made Easy
A Beginner's Workbook

Calligraphy Projects
for Pleasure and Profit

Calligraphy Now
New Light on Traditional Letters

Calligraphy Calendar

Borders for Calligraphy

How to Design a Decorated Page
Revised and Expanded

MARGARET SHEPHERD

Collier Books · Macmillan Publishing Company · New York

Macmillan Publishing Company

866 Third Avenue, New York, N.Y. 10022

Collier Macmillan Canada Ltd.

LIBRARY of CONGRESS CATALOGING in PUBLICATION DATA

Shepherd, Margaret.
 Borders for calligraphy.

 Bibliography: p.
 1. Borders, Ornamental (Decorative arts)
 2. Calligraphy. I. Title.
NK3630.4.B67552 1985 745.6'1 84~21370
ISBN 0~02~029560~X

First Collier Books edition 1980

First printing 1984

Printed in the United States of America

For David

TABLE OF CONTENTS

Using This Book ix
Acknowledgements xi

I.
MATERIALS AND SOURCES 1

II.
LETTERS ON THE WHOLE PAGE 11

III.
INITIALS GROW INTO BORDERS 29

IV.
ORNAMENT HARMONIZES
WITH LETTER STYLE 37

V.
COLOR ILLUMINATES STYLE 57

VI.
BORDERS TO ILLUMINATE 81

VII.
SPECIAL TECHNIQUES AND
DESIGN IDEAS 117

USING THIS BOOK

Love of letters leads naturally to love of the page. Calligraphy expands your vision to include not just the letters but the ornamentation that borders those letters.

BORDERS FOR CALLIGRAPHY enables you to translate your interest in letters into an understanding of borders, no matter what your calligraphy skills are. If you are a beginner, try the simple yet very educational exercise of adding the historically correct colors to the lettered and bordered quotations in chapter V. If you are a student, paint your own color schemes and letter your own quotes in the border outlines in chapter VI. If you are a practicing calligrapher, you can duplicate, cut, and paste border sections for reproduction from chapter IV, or adapt them for your own layouts. If you are a master craftsman, the exercises and sketches in chapters II and III can suggest new directions for your own original designs. And whatever your level, you may enjoy one of the quotations from the historical color lessons or the chapter headings enough to take it out of the book's binding and frame it.

Borders form one area of calligraphy where unexpected talents can shine. Left-handers are at no disadvantage; coloring-book techniques are not only acceptable but sometimes essential; genius is less important than patience. Borders demand patience—but they also teach patience and richly reward it.

Looking at borders can teach you about the dynamics of the whole page—how the style, color, and proportion of the letters and ornament work with the text, to clarify, enhance, and illuminate the author's thought. Many of the fundamental principles of the writer's craft can guide as well the scribe in his search for unity of word and image. Strive to make the design as informative as the words:

"Vigorous writing is concise. A sentence should contain no unnecessary words, a paragraph no unnecessary sentences, for the same reason that a drawing should have no unnecessary lines and a machine no unnecessary parts. This requires not that the writer make all his sentences short, or that he avoid all detail and treat his subjects only in outline, but that every word tell."*

Whatever your artistic skills, if you appreciate the charms of a well-written quotation, BORDERS FOR CALLIGRAPHY can help you turn it into a handsome manuscript page of calligraphy and illumination. Discover the world of the scribes who for centuries have made words mean more by making them beautiful.

Margaret Shepherd
1 September 1980
Boston

* William Strunk, Jr., and E.B. White,
 THE ELEMENTS OF STYLE (New York:
 Macmillan Publishing Co., Inc., 1972), pp ix-x.

ACKNOWLEDGEMENTS

I wish to thank those who helped me with this book. The Cecile de Banke memorial glass roundel on page 77 was designed by Eleanor Blair and executed by Francis R. Barberio, and is pictured by courtesy of the Wellesley College Library. I am indebted to the staff of Hatfield's Color Shop for advice on materials, and to Marc Drogin, whose learned essay in the Society of Scribes and Illuminators Newsletter unmasked the demon Titivillus once and for all.

My husband and son deserve special thanks for living with me while I thought this book up, collected the ideas, wrote the text, drew the illustrations, and weeded out the errors that sometimes seemed to outnumber the accuracies. If you call that living...

Finally, I am greatful to my students and readers whose questions, I am certain, have taught ME more than my answers could ever teach THEM.

Materials I and Sources

I have made it my concern
to hunt out this technique for
your study as I learned it
by looking and listening.

ON DIVERS ARTS · THEOPHILUS

MATERIALS AND SOURCES

The materials you need for the borders in this book are for 3 different stages: (1) rough draft, (2) black-and-white finished execution, and (3) coloring and gilding. Don't skip the valuable ROUGH DRAFT stage! Arm yourself with one wide and one narrow calligraphy fountain pen, some calligraphy felt pens in various colors, a guideline sheet, and a stack of cheap paper. Work on your layout over and over. Don't worry about how the individual letters look; just make them fit together on the page.

A number of inks are suitable for calligraphy felt pens; e.g, Pelikan 4001, Higgins Eternal. India ink is too thick to flow through a fountain pen; regular fountain pen ink is too thin to cover well; calligraphy ink is in between.

A soft, white, non-abrasive eraser or "Art Gum" type eraser to remove pencil lines.

Magic Rub®
1954
Non-Abrasive Non-Smudging
Vinyl for Erasing Drafting Film
FaberCastell

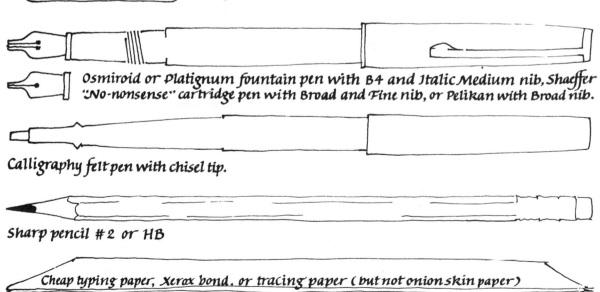

Osmiroid or Platignum fountain pen with B4 and Italic Medium nib, Shaeffer "No-nonsense" cartridge pen with Broad and Fine nib, or Pelikan with Broad nib.

Calligraphy felt pen with chisel tip.

Sharp pencil #2 or HB

Cheap typing paper, Xerox bond, or tracing paper (but not onion skin paper)

BLACK-AND-WHITE finished work in pen and ink takes two kinds of materials: pencil, eraser, T-square or triangle, and cork-backed metal ruler, for planning and sketching in detail; and India ink, dip pen for lettering, and technical fountain pen or crowquill for drawing. Work carefully from your rough draft and aim for precision.

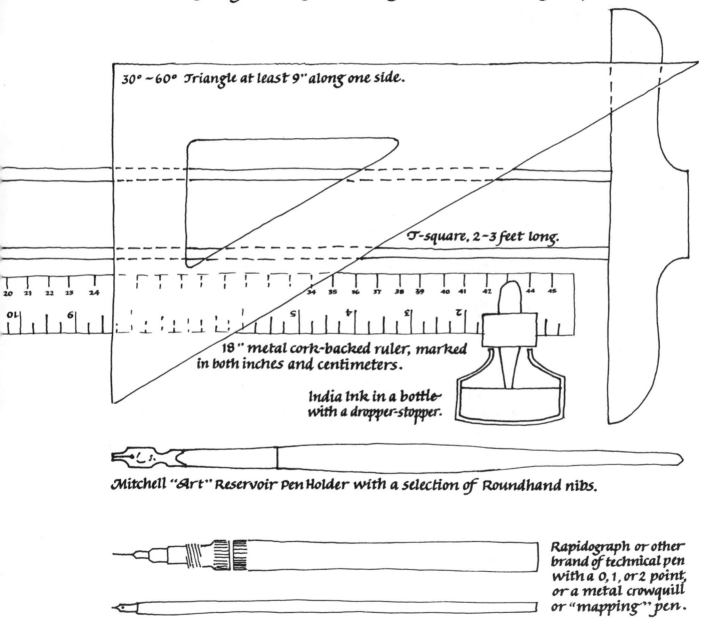

30° ~ 60° Triangle at least 9" along one side.

T-square, 2~3 feet long.

18" metal cork-backed ruler, marked in both inches and centimeters.

India ink in a bottle with a dropper-stopper.

Mitchell "Art" Reservoir Pen Holder with a selection of Roundhand nibs.

Rapidograph or other brand of technical pen with a 0, 1, or 2 point, or a metal crowquill or "mapping" pen.

Choosing paper will be much easier if you know how it is made. The drawings here show what you can't see. Paper begins with a watery pulp spread on screens that let the water drain off. (The better the paper, the less wood pulp & the more rag content.) The paper at this stage has a soft, absorbent surface like a blotter (1), which is covered with a thin layer of glue called 'size' (2) to help keep the ink from sinking in. While calligraphers should avoid unsized papers, they should also be wary of too thickly sized papers (3); the ink will not penetrate the size to make proper contact with the paper (4). Look for lightly sized papers. Some in lighter weights have a 'laid' finish (5), where the texture of the screen shows as faint horizontal lines. Heavier weights with a 'wove' finish are uniform all over (6). Note also the difference between 'Hot press' or 'plate' Bristol board (7), and 'cold press' or 'vellum' Bristol board (8). Some heavy papers are sized on only one side (9). Finally, parchment transcends all the rules about paper, and can provide the ideal surface for ink and pigment (10).

ink

(1). UNSIZED PAPER
Tissue paper, Oriental watercolor paper. Not recommended.

(2). SIZED PAPER
Rag typing paper

(3). TOO THICKLY SIZED PAPER
Imitation ('vegetable') parchment paper

(4). PROPERLY SIZED PAPER

(5). LAID PAPER
Stratmore Calligraphy Manuscript Paper; 3 Candlesticks Paper

(6). WOVE PAPER
Ledger bond

(7). HOT PRESS (8). COLD PRESS
Bristol bond (mounted on board)

(9). PAPER SIZED ON ONE SIDE
Arches Satine paper, Rives BFK, Strathmore Calligraphy Document Paper

(10). PARCHMENT or VELLUM
'Kelmscott' finish

COLOR is handled in two forms, transparent and opaque. Transparent color is available as a liquid in bottles, a solid in watercolor sets, a soft paste in tubes, or a powder in jars. Any of these watercolors can be made opaque by mixing with white to make gouache. Liquid colors may be used with a dip pen or a brush; the others require a brush. When you work with color in any form, strive for cleanliness of brush, pallette, and water to ensure clarity and brilliance of hue.

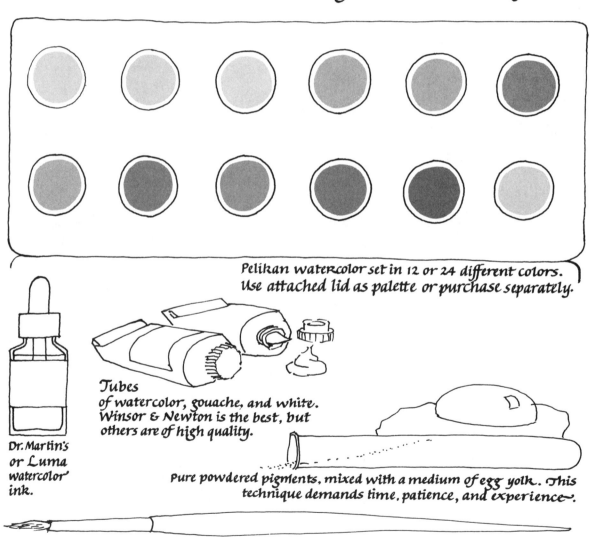

Pelikan watercolor set in 12 or 24 different colors. Use attached lid as palette or purchase separately.

Dr. Martin's or Luma watercolor ink.

Tubes of watercolor, gouache, and white. Winsor & Newton is the best, but others are of high quality.

Pure powdered pigments, mixed with a medium of egg yolk. This technique demands time, patience, and experience.

Winsor & Newton #2 brush.

Gold is applied to the page in two completely different ways. GOLD PAINT made of real gold powder comes in shell or tablet form; imitation gold paint is available as liquid or solid. Also, you can try various shades of imitation gold, brass, bronze, copper, silver, and other metals in powder form.

24 K real gold powder paint in tablet and shell forms.

'Gold' ink in bottle and pan.

GOLD LEAF, on the other hand, demands its own specialized set of tools and materials: gesso (raising preparation), gold leaf, silk and velvet daubers to position the gold leaf on the gesso, and burnishers to bond it to the gesso.

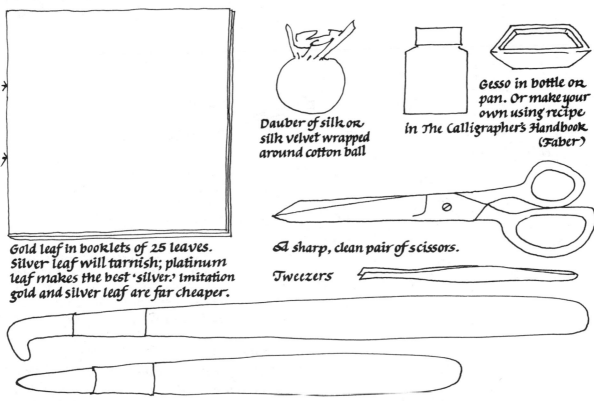

Dauber of silk or silk velvet wrapped around cotton ball

Gesso in bottle or pan. Or make your own using recipe in The Calligrapher's Handbook (Faber)

Gold leaf in booklets of 25 leaves. Silver leaf will tarnish; platinum leaf makes the best 'silver.' imitation gold and silver leaf are far cheaper.

A sharp, clean pair of scissors.

Tweezers

Agate, hematite, or dog-tooth burnishers smooth and polish the gold leaf on the gesso.

Your workspace should be designed to fit your individual needs and habits. If you letter only once in a while or for only a short period at a time, or if you like to spread your materials out around you, a flat table with good light coming from your left* will suffice. Many calligraphers find that if they do more than an hour of lettering in a day they need the comfort of a sloping work surface. There are many ways to achieve this, some of which are shown below.

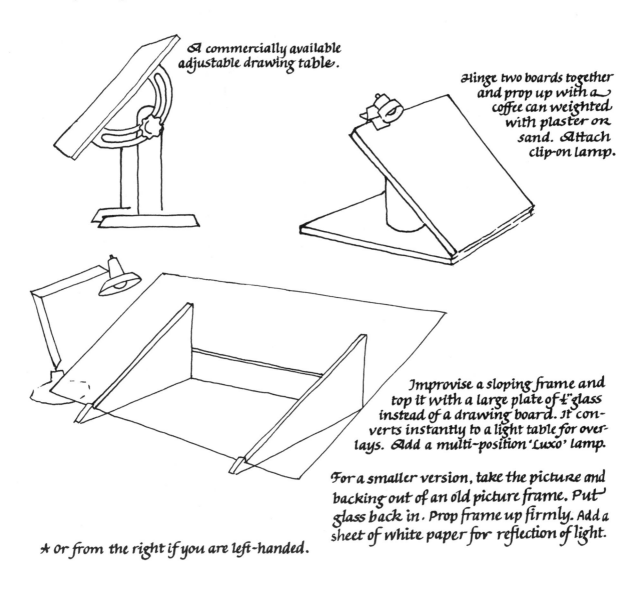

A commercially available adjustable drawing table.

Hinge two boards together and prop up with a coffee can weighted with plaster or sand. Attach clip-on lamp.

Improvise a sloping frame and top it with a large plate of ¼" glass instead of a drawing board. It converts instantly to a light table for overlays. Add a multi-position 'Luxo' lamp.

For a smaller version, take the picture and backing out of an old picture frame. Put glass back in. Prop frame up firmly. Add a sheet of white paper for reflection of light.

* Or from the right if you are left-handed.

The best way to learn about materials is to start with the ones shown here as a nucleus. Try them with an open mind, gradually adding new materials, tools, and techniques. Watch other scribes at work in demonstrations, lectures, and classes. Join a calligraphers' organization and share know-how. Read calligraphy books and newsletters.

Angel, Marie. The Art of Calligraphy. New York: Charles Scribner's Sons, 1977.

Bain, George. Celtic Art: The Methods of Construction. New York: Dover, 1974.

The Book of Kells. New York: Alfred A. Knopf, 1974.

David, Ismar. Our Calligraphic Heritage. New York: Geyer Studio, 1979.

Gray, Bill. Studio Tips for Artists and Designers. New York: Van Nostrand Reinholt, 1976.

Gray, Bill. More Studio Tips for Artists and Designers. New York: Van Nostrand Reinholt, 1978

The Hours of Catherine of Cleves. New York: George Braziller, 1966.

Lamb, C. M., ed. The Calligrapher's Handbook. London: Faber, 1956.

Theophilus. On Divers Arts. New York: Dover, 1963

Thompson, Daniel V. The Materials and Techniques of Medieval Painting. New York: Dover, 1956.

Catalogs are available from Dover Publications, 180 Varick Street, New York, N.Y., 10014; George Braziller, One Park Avenue, New York, N.Y. 10016, and Pentalic, 132 West 22nd Street, New York, N.Y. 10017

Here are the addresses of the makers of many of the materials listed in this chapter.

H. Band & Co., Brent Way, High Street, Middlesex, England. Parchment and vellum.

Cooper Color, 3006 Mercury Road South, Jacksonville, Florida, 32207. Chiz'l pen.

Cumberland Graphics, 134 Old Street, London, E.C.2, England. Mitchell pens and nibs.

John Dickenson, c/o Pentalic, 132 West 22nd Street, New York, N.Y. 10017. '3 candlesticks.'

Eberhard Faber, Crestwood, Wilkes-Barre, Pennsylvania, 18703. Design-art pen.

Faber Castell, Newark, N.J., 07103. Eraser & Higgins ink.

Osmiroid, E.S. Perry Ltd., Gosport, Hamps., England.

Pelikan, Günther Wagner, D3000, Hannover, West Germany. Ink, pens, and watercolors.

Platignum House, Stevenage, Hertfordshire, England.

Salis International, Hollywood, Florida, 33020. Dr. Martin's Inks.

Sheaffer, Pittsfield, Massachusetts, 01201. 'No-nonsense' pen.

Steig Products, Lakewood, N.J. 08701 Luma Inks.

Strathmore Paper Company, Westfield, Massachusetts.

Winsor & Newton, Wealdstone, Harrow, Middlesex, England. Brushes, paints, and gesso.

Distributors and mail-order firms are not given because they change often. Write or call the manufacturer to find out the retail source nearest you.

Only in the presence of these
magnificent objects from antiquity,
does one realize that there is no past in
art, but only an exciting present illuminated
with the wise smile of the past.

OSSIP ZADKINE

LETTERS ON THE WHOLE PAGE

Working with borders makes you look at the whole page. You must pull your eye away from the individual letters to focus instead on their overall effect.

In this chapter we will look at each of the five major historical alphabets, not primarily to study each letter but to learn the lessons that each alphabet can teach us about the art of page layout. An understanding of these principles is indispensable when you design a page. Don't attempt to add borders to your page until you can work intelligently and creatively with the letters.

A few suggestions will help you get the most out of the exercises in this chapter:

1. The lessons are for review if you have already had some calligraphy experience, or a brief introduction if you are a beginner. If the lesson seems too easy, speed up. If it seems too difficult, slow down.

2. If you are a beginner, remember that you are not only learning about letters but also familiarizing yourself with the pen. If necessary to avoid bogging down, choose the simplest letter style and concentrate on it.

3. Copy the alphabets and techniques by laying a sheet of practice paper over the special Guideline Sheet on page 43 so that the lines show faintly through.

4. Use a penpoint of this width: ▎

(Osmiroid or Pentalic Broad, Shaeffer Fine, Pelikan Broad, or Mitchell Roundhand #3.)

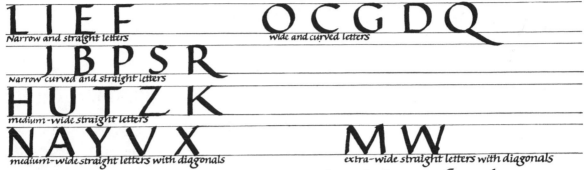

L I E F O C G D Q
Narrow and straight letters *wide and curved letters*

J B P S R
Narrow curved and straight letters

H U T Z K
medium-wide straight letters

N A Y V X M W
medium-wide straight letters with diagonals *extra-wide straight letters with diagonals*

ROMAN *LETTERS* are divided into family groups by their width, pen angle, and basic shape. Study these categories above, noticing how each letter relates to a basic square, rectangular, or circular outline. Note, also, subtleties like slightly above- or below-center joining of cross-strokes, very precise corners, and nearly straight "curved" tails. ⌐This alphabet was perfected in first-century Roman carvings.

Keep a 20° pen angle for all but the last 7 letters.

Aa a a b b b c o d d d e
f f g s g h h h i j k k l n
m n n n o p p q r r s s
t t u u v w x x y y z 9

CELTIC *LETTERS* are an eighth-century Irish version of the broader category of Uncials popular from 500 A.D. to 1000 A.D. They are characterized by the large number of alternate letters (variants), the elastic, coil-like outlines, and the distinctive Celtic serif, made of two superimposed strokes of the pen.

The 2-stroke wedge serif characterizes Celtic letters.

itljfz unhvykmw
1-line letters *open-top & bottom letters*

obqpdg cera z s
Closed letters *open-side letters*

GOTHIC LETTERS were the dominant Medieval style from 1000 A.D. to 1500 A.D. All the letters are derived from the O shape. They are extremely uniform; the white space inside the Gothic letter is equal not only to the spaces between the letters but also to the width of the black penstrokes themselves

Gothic letters are all made up of squares & strokes.

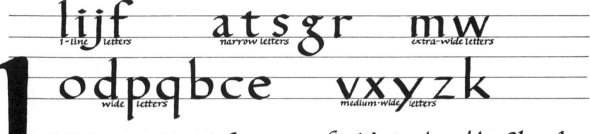

lijf atsgr mw
1-line letters *narrow letters* *extra-wide letters*

odpqbce vxyzk
wide letters *medium-wide letters*

BOOKHAND LETTERS, first introduced by Charlemagne's scribes in 800 A.D., were revived and refined in 1500 A.D. They keep some of the Roman letter groups and harmonize with the capitals.

Many letters are upside-down versions of each other.

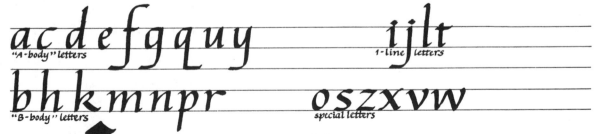

acdefgquy ijlt
"A-body" letters *1-line letters*

bhkmnpr oszxvw
"B-body" letters *special letters*

ITALIC LETTERS, a fifteenth-century innovation of the Italian Renaissance, are built around two basic triangular letter body shapes. Even the swashes follow these angular outlines.

Italic letters are derived mainly from the 2 basic shapes of the A & B.

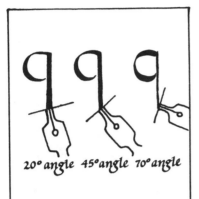

20° angle 45° angle 70° angle

Your first exercise in pen variations is a change in PEN ANGLE. This puts the thick and thin strokes in different places.

ABCDEFGHIJKLM
NOPQRSTUVWXYZ

These Roman letters, for example, have a steep angle. Try varying other alphabets.

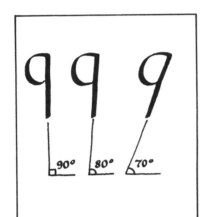

90° 80° 70°

Now alter the LETTER ANGLE. Don't overdo it. A small slant has a big effect; too much can make the letters fall over.

ABCDEFGHIJKLM
NOPQRSTUVWXYZ

These Celtic letters, for example, have a slant of 10°. Try varying other alphabets.

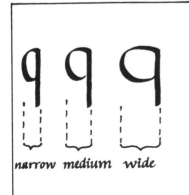

narrow medium wide

Then modify the LETTER WIDTH, to make all the letters wider or narrower.

abcdefghijklmno
pqrstuvwxyz.z
abcdefghijklmnopqrstuvwxyz

These Gothic letters, for example, are wider & narrower. Try varying other alphabets.

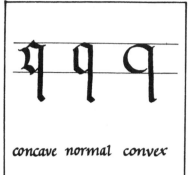

concave normal convex

Next, change the ANGULARITY of the letter by making it more convex or concave, as if air were being pumped in or out of it.

abcdefghijklm
nopqrstuwxyz

These Bookhand letters, for example, are squared off. Try varying other alphabets.

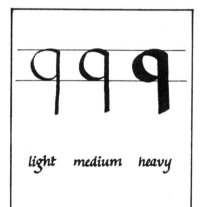

light medium heavy

A further pen modification affects the BOLDNESS of the letter, by changing either the pen width or the letter height.

abcdefghijklmn
opqrstuvwxyz

These Italic letters, for example, are of a lighter weight. Try varying other alphabets.

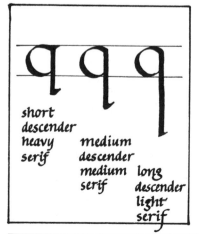

short
descender
heavy medium
serif descender
 medium long
 serif descender
 light
 serif

Finally, endless variations come from changing the shape of the SERIF and the length of the ASCENDERS & DESCENDERS.

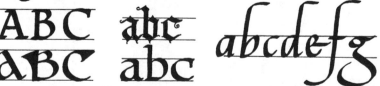

ABC abc
ABC abc
abcdefg

Here are a few suggestions for this kind of variation. Try varying whole alphabets.

GOD IS SUBTLE
BUT HE IS NOT
MALICIOUS ⚜
RAFFINIERT IST
DER HERR GOTT
ABER BÖSCHAFT
IST ER NICHT.

3

GOD IS SUBTLE BUT
HE IS NOT MALICOUS.
I CANNOT BELIEVE
THAT GOD PLAYS
AT DICE WITH THE
UNIVERSE.

ALBERT EINSTEIN
from OUT OF
MY LATER YEARS

6

The Roman alphabet demonstrates here the varied effects of RELATIVE LETTER SIZE, or the number of letters you put into a given space. Roman letters communicate clearly whether written large or small (although they can be tiring to read as a very small text letter if used page after page), so they make a good choice for inscriptions and short quotations. In general, the fewer letters on a page, the more formal you can make them, planning them thoroughly, executing them carefully, and retouching them painstakingly. Also, as a rule of thumb, you may find that the smaller the alphabet the more appropriate a border or an initial decoration. The large letters seem to function as their own ornamentation. Try various sizes; the execution of both large and small letters will strengthen your technique.

LET US
NOT BE TOO
PARTICULAR.
IT IS BETTER
TO HAVE OLD
SECONDHAND
DIAMONDS
THAN NONE
AT ALL. MARK TWAIN

1

Let us
not be too
particular.
It is better
to have old
secondhand
diamonds
than none
at all. MARK TWAIN

2

LET us
not be too
PARTICULAR.
IT IS BETTER
to have old
secondhand
diamonds
than none
at all. MARK TWAIN

4

Let us
not be too
particular.
It is better
to have old
secondhand
diamonds
than none
at all. mark twain

5

LET US
not be too
particular.
it is better
to have old
secondhand
diamonds
than none
at all. MARK TWAIN

3

LET US
not be too
particular.
it is better
to have old
secondhand
diamonds
than none
at all. MARK TWAIN

6

The Celtic alphabet, with its vast resources of alternate letters, illustrates the overall effect of VARIANTS. Even one or two different letters can alter the visual texture of the piece (see examples 1, 2, 4, and 5 opposite). Alternatively, try a slight change of SERIF (see examples 3 and 6 on this page). Both of these changes, although minor in scale and subtle in effect, help to attune your eyes to the abstract message that letters always contain for your visual understanding. You can teach your eyes in other ways. Look critically at the books and newspapers you read every day. How do the letters look as a mass? Is the effect rich or simple, aloof or inviting, vigorous or elegant? Does any letter stand out more than the rest? Learn to see these elements and use them intelligently in your designs.

1

Dancing in all its
forms cannot be ex-
cluded from the cur-
riculum of a noble
education: dancing
with the feet, with
ideas, with words,
and need I add that
one must also be able
to dance with the pen?

Nietzsche

2

Dancing in of a noble
all its forms education:
cannot be Dancing
excluded with the feet,
from the with ideas,
curriculum with words,

and need I add that one must
also be able to dance
with the pen?

Nietzsche

4

Dancing in all its
forms cannot be ex-
cluded from the cur-
riculum of a noble
education: dancing
with the feet, with
ideas, with words,
and need I add that
one must also be able
to dance with the pen?

Nietzsche

5

Dancing in with the feet,
all its forms with ideas,
cannot be with words,
excluded and need I
from the add that
curriculum one must
of a noble also be able
education: to dance
Dancing with the pen?

Nietzsche

Dancing in all its forms cannot be excluded from the curriculum of a noble education ⁖ Dancing with the feet, with ideas, with words, & need I add that one must also be able to dance with the pen?

Nietzsche

3

Dancing in all its forms cannot be excluded from the curriculum of a noble education: Dancing with the feet, with ideas, with words,

and need I add that one must also be able to dance with the pen?

Nietzsche

6

The Gothic alphabet gives you the chance to experiment with THE SHAPE OF THE TEXT itself. While eye-catching shapes like example 6 on this page are fun for calligrapher and viewer alike, you should find it equally challenging to study the proportions of simple rectangular shapes. You'll first need to solve some problems of technique — how to make the quotation fit the space provided and how to be sure all the lines come out the same length. Make liberal use of pencil and eraser to sketch in each line. Study copies of medieval manuscripts to see how scribes controlled the line length with letter s p a c i n g abbrev., and ornament. Start thinking, too, about some problems of visual expertise— how to suit the text shape to both the letter and the page. What makes good proportion?

Y o u

m u s t

l e a r

n t o c

h o o s

e b e -

1

You m u s t

learn to

choose be-

t w e e n.

One hap-

py thing

3

You m u s

t l e a r n

to c h o

o s e b e

t w e e n.

O n e h a

2

You must learn

to choose

b e t w e e n.

One happy

thing is ev-

ery happy

4

You must learn
to choose be-
tween. One happ
y thing is ever-
y happy thing.
Two is as if th

5

You must learn to
choose between.
One happy thing is
every happy thing.
Two is as if they
had never been.

Histoire d'un Soldat

6

The Bookhand alphabet can help you learn the mechanics of LETTERSPACING. Unlike Gothic, where the spaces inside and between letters are pretty rigidly preordained, the spacing of Bookhand can be elastic. The letters can tolerate being somewhat closer together or farther apart without seeming awkward or illegible. It is this adaptability that has made lowercase Roman, the typographic counterpart of Bookhand calligraphy, the most common text letter of the last 500 years of printing. Experiment with letterspacing to accustom yourself to wide and narrow spacing. Then apply this knowledge to the problem raised in the previous lesson: how to make slightly uneven lines all come out the same length. This skill can open many new avenues for calligraphic experiment.

Discipline must be
sought in freedom &
not within the form-
ulas of an outworn
philosophy only fit
for the feebleminded.
Give ear to no man's

1

Discipline must be
sought in freedom &
not within the form-
ulas of an outworn
philosophy only fit
for the feebleminded.
Give ear to no man's
counsel; but listen
to the wind which

3

Discipline must be
sought in freedom &
not within the form-
ulas of an outworn
philosophy only fit
for the feebleminded.
Give ear to no man's
counsel; but listen

2

Discipline must be
sought in freedom &
not within the form-
ulas of an outworn
philosophy only fit
for the feebleminded.
Give ear to no man's
counsel; but listen
to the wind which
tells in passing the

4

Discipline must be
sought in freedom &
not within the form-
ulas of an outworn
philosophy only fit
for the feebleminded.
Give ear to no man's
counsel; but listen
to the wind which
tells in passing the
history of the world.

5

Discipline must be
sought in freedom &
not within the form-
ulas of an outworn
philosophy only fit
for the feebleminded.
Give ear to no man's
counsel; but listen
to the wind which
tells in passing the
history of the world.

EDGAR VARESE

6

The Italic alphabet lets you try out LINESPACING. This simple ingredient of overall texture can range from several times the height of the letter body, to less than its height. As the space increases, you can lengthen the ascenders and descenders. You may want to combine these variations in linespacing with changes in letterspacing, as shown here, to ensure that your letters will stay clearly legible. Thus, as the lines come close together, the letterspacing gets tighter. The open, airy textures from Examples 1 and 2 are more suitable for poetry, while the solid, dark textures of 5 and 6 are better for prose. There is, however, no prescription for the 'right' way to lay out your quotation, just the ongoing process of learning to reconcile the needs of the quote to the demands of your layout.

These, then, are the fundamental calligraphy skills that you should become familiar with: the main historical alphabets, variations on these styles through pen manipulation, and techniques for arranging these letters on a page. Before you begin to add borders, review these three skills to deepen your understanding, and practice them to strengthen your hand. Repeat the basic alphabets, striving for precision, so that you can concentrate on their overall texture. Experiment with variations to learn about the capabilities of the pen. Try many different ways of grouping letters on the page, with the goal of understanding the principles of good layout. Get your feet firmly under you before you take the next big design step.

But there are also a few things that you should NOT do. Don't work with tools or materials that are too advanced for you, that make you awkward, strained, or hesitant in your lettering. Don't try to memorize arbitrary rules as answers to the problems of spacing, style, proportion, and design. The challenges and satisfactions of calligraphy derive from the fact that there are no hard and fast, simple answers. Each calligrapher learns from observation and experience, developing a unique approach of his own. Don't copy the work of other calligraphers. This is boring for you to do and boring for others to look at. And finally, don't pay too much attention to the teacher or kibitzer whose advice goes against your own best instincts. Evaluate it for what it is worth to you and your work, but at the same time learn to trust your own esthetic judgment and your own visual taste.

Initials Grow Into Borders

*An artist should never lose sight of
the thing as a whole.
He who puts too much into details
will find that the thread which holds
the whole thing together will break.*

FREDERIC CHOPIN

INITIALS GROW INTO BORDERS

1.

Now you can start laying out a page of calligraphy that includes a border, integrating these two separate elements into one unified work of art. Borders are not letters — often they are executed with two completely different sets of tools — but they inhabit the same page and must harmonize visually. It is simplest to begin your lesson in decoration with the INITIAL. Start with a medium-length text of 50 words or so (1). Experiment by gradually increasing the size of the first letter to see how its emphasis changes the balance of each page (2~4). Block in a square area in back of the letter (5). Now,

2.

3.

4.

5.

indent the letter all the way into the para-
graph (6); then halfway (7); and then
leave it hanging in the margin, outside
the block of letters (8). (You can enlarge
the remaining letters of the first word to
fill the first line if you keep them small-
er than the large initial.) Try also the
effect of a second, smaller initial far-
ther down the page (9).

 Next decorate the
enlarged, boxed-in initial with PATTERN
appropriate to the historical style of the
calligraphy (see "Ornament Harmon-
izes with Letter Style," pages 31 – 44).
Add foliage behind the initial (10). Ex-
tend the foliage beyond the boundaries
of the box (10). Gradually extend it to
fill up one margin (11).

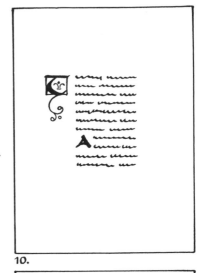

10.

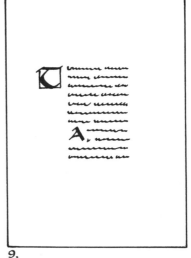

9.

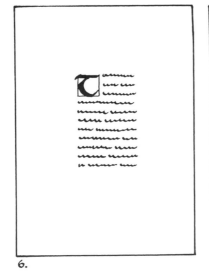

6.

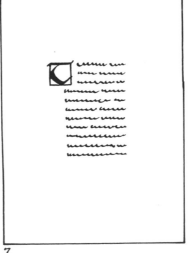

7.

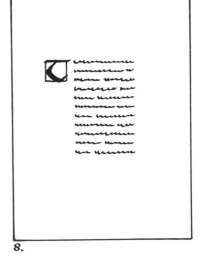

8.

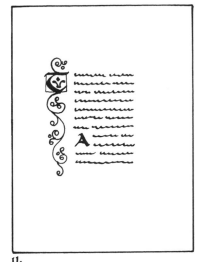

11.

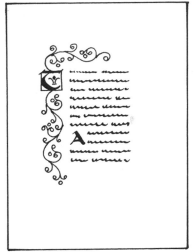

12.

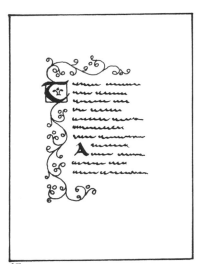

13.

Extend the foliage from the bottom (11) and the top (12) of the left border. This asymmetrical border could be used successfully to balance the uneven right edge of a "ragged-right" calligraphy layout (13). The border can extend farther (14) until it encloses the calligraphy completely (15).

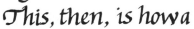

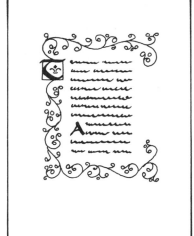

14.

This, then, is how a border "grows." The sequence shown in the fifteen examples here represents the gradual historical evolution of the illuminated border during the centuries between the fall of the Roman Empire and the Renaissance. You can choose from any stage of this growth and be assured of a balanced, coherent layout that works well visually.

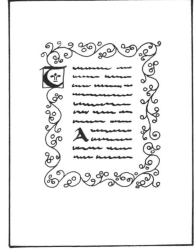

15.

If you want a more formal, perhaps less naturalistic and more abstract border, go in the other direction. Start with an indented initial and a border made up of repeating sections (16), and gradually subtract elements to make a balanced page (17, 18, and 19). These designs are characteristic of post-Renaissance designs of the last five centuries. Experiment a little. Sometimes one segment of border has more effect than the whole thing (20).

These border lay-outs are shown here as "thumbnail" sketches, to help you get into the habit of visualizing and sketching your own layouts this way. It can save you work and produce a stronger, simpler design.

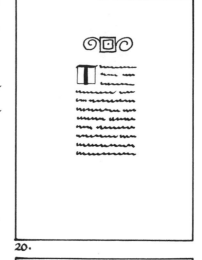

20.

19.

16.

17.

18.

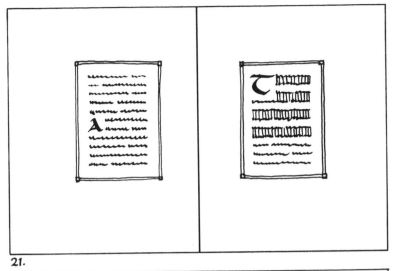

21.

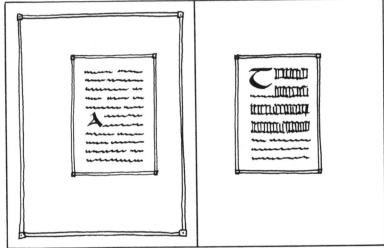

22.

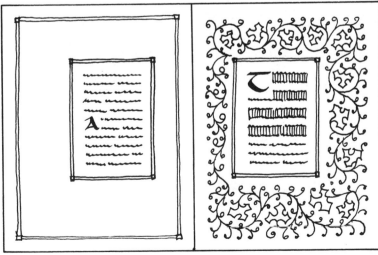

23.

A further lesson applies to the layout of a two-page spread—how to handle the graphic ingredients of the open book. In general, keep the text areas identical in size and shape (21), leaving the same margin space for borders, whether you use it or not. The two pages can be different in color, in decoration, in ornateness, and even in letter style and size (22 and 23), if they preserve this unity of proportion. These examples are typical of many late Medieval and early Renaissance manuscripts.

Don't forget the borders of the twentieth century. Calligraphy and illumination have both undergone a contemporary renaissance. Modern manuscript design offers the calligrapher many special challenges. Borders can be stripped to their essentials, in keeping with the philosophy of "less is more" (24, 25). Or, traditional borders can be used in non-traditional layouts (26, 27), abandoning the rectangular text. Finally, borders can mingle with letters, to bridge the gap between the two different elements on the page (28, 29).

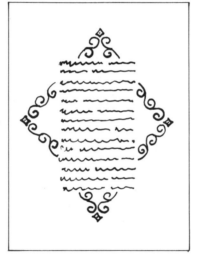

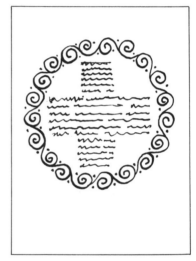

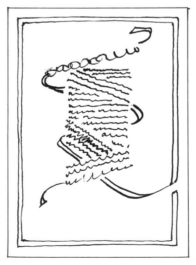

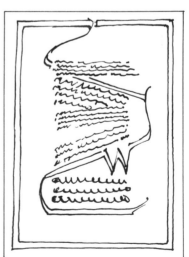

But, after all, the only principle in art
is to copy what you see.
Dealers in aesthetics to the contrary,
every other method is fatal.
There is no recipe for improving nature.
The only thing is to see.

AUGUSTE RODIN

ORNAMENT HARMONIZES WITH ALPHABET STYLE

With your border and letters planned in general proportions, you can now turn to questions of style. Choosing a LETTER STYLE depends on a subtle balance of ingredients: legibility, density, historical or national references in the quotation, and your own abilities as a scribe. Choosing a DECORATIVE STYLE to harmonize with the letter style involves just as many factors: the size, style, weight, and proportion of the text area; the amount and strength of color you intend to use; the degree of formality; and the mutual historical roots of letter and ornament. Even a "mismatched" design — an Irish quotation, Gothic lettering, and Roman border, for example — can be made to appear visually unified and attractive to the uncritical viewer. But why not put that extra bit of knowledge and planning into your work to achieve a real intellectual unity?

This chapter gives you all you need to combine letters and ornament on the page, without trial and error or excessive toil. The letters, initials, borders, and guideline sheets given here are a convenient shortcut to help you get started designing whole pages. They are not a set of rules or models. You should use them and move on from them. Stay with the prescribed layout just for this chapter; it will free you from preliminary layout calculations so that

you can concentrate on problems of execution. To aid this process, borders are shown with corner pieces & 'repeats' to fit the Border Guideline Sheet.

As you go along, pay attention to how these borders are styled. Some, like Gothic, are realistic, reflecting the artist's preoccupation with the minutest details of everyday life. Others, like Roman, are highly abstract and formal. Still others, like Celtic, combine naturalistic with geometric elements to make a uniquely fanciful and ornate national style.

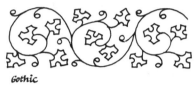

Gothic

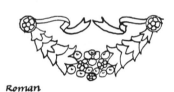

Roman

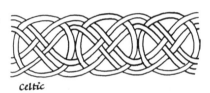

Celtic

Notice also how the borders are executed. PEN-LETTERED forms, whether they are letters or decoration, are done with one stroke of the broad-nib pen, while DRAWN-AND-FILLED-IN forms are outlined with a thin pen and then colored in with a brush. The first is faster, the second more precise.

Pen-lettered border elements

Drawn-and-filled-in border elements

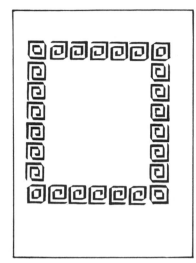
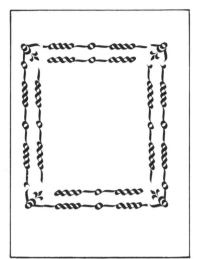
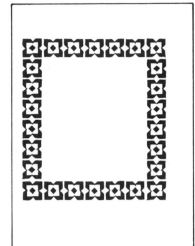

Start by studying and comparing these two techniques of borders. How do their final effects differ? Think about what suits the quotation you have chosen: the informal, handmade, forceful look of pen-lettered borders, or the formal, fine, reserved appearance of drawn-and-filled-in ornament. Consider also your own patience, ability, and taste: are you more interested in exploring the potential of your calligraphy pen, or do you find more challenge in combining letters and drawing on the same page?

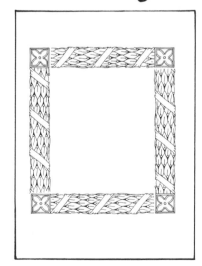
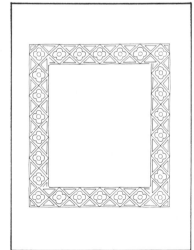
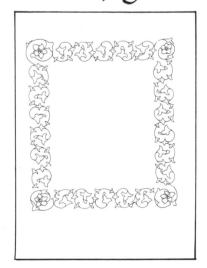

Here are three simple, "all-purpose" pen borders to try first. They will help familiarize you with how to lay out borders on the special guideline sheet provided on page 43. Fasten a piece of practice paper over the Guideline Sheet. Choose a chisel-tip felt pen, fountain pen with B4 nib, #1 Mitchell pen, or other broad-edge pen of approximately this width **I**.

Start with the first border below. Do the corners. Draw circles at the line between each border unit. Finish all the circles before you go on to add the dashes; that way, you build up the whole border evenly rather than finishing each unit before going ahead with the next.

Turn the paper (and guideline sheet) sideways for the border sides, to help keep the correct 45° pen angle used in most of the pen-lettered borders.

Step 1: Corners

Step 2: Divisions

Step 3: Connections

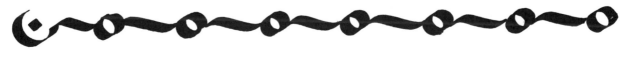

Drawn-and-filled-in borders require different techniques as well as different tools. Use a thin crowquill, #6 Mitchell, or technical fountain pen. Lay a sheet of practice paper over the Guideline Sheet (page 43). Trace with pencil the border guidelines. They don't have to be ruler-perfect; just get the proportions & intersections

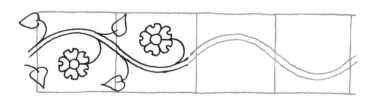

right. Now choose a border style and look at it. Trace and sketch with pencil any continuous element like a stem or band. Now, using a pen, trace (if you're a beginner,) copy (if you're intermediate) or adapt (if you're advanced) the design one section at a time. Finish each section before doing the next one.

To try out several borders quickly in rough draft, make six Xerox copies of the desired border page. Cut them into strips and assemble your layout. As you eliminate tedium, you will make better design choices.

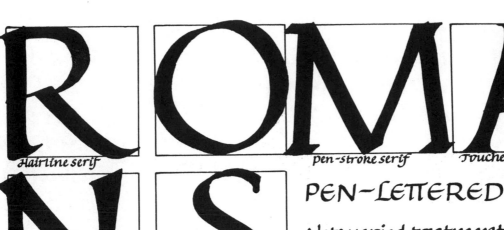

Hairline serif pen-stroke serif Touched-up serif

Turned-pen serif Pulled-ink serif

PEN-LETTERED

Note varied treatments of the
serif, including touch-up with
a smaller pen on A and S.

THE ROMAN

Roman pen-lettered borders can come from pre-Roman Greek geometric fabric and pottery designs.

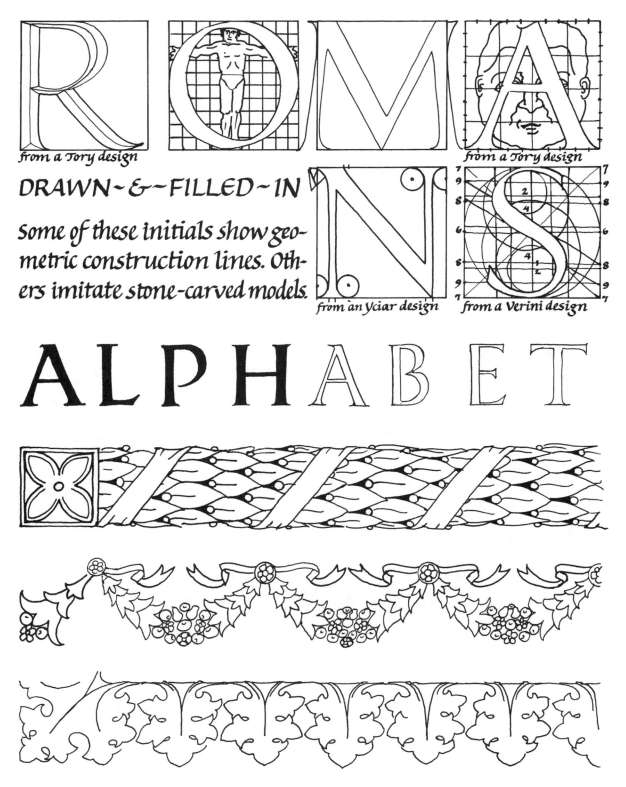

from a Tory design

from a Tory design

DRAWN ~ & ~ FILLED ~ IN

Some of these initials show geometric construction lines. Others imitate stone-carved models.

from an Yciar design

from a Verini design

ALPHABET

Many Roman borders represent sheaves or garlands or bands of ceremonial plant offerings.

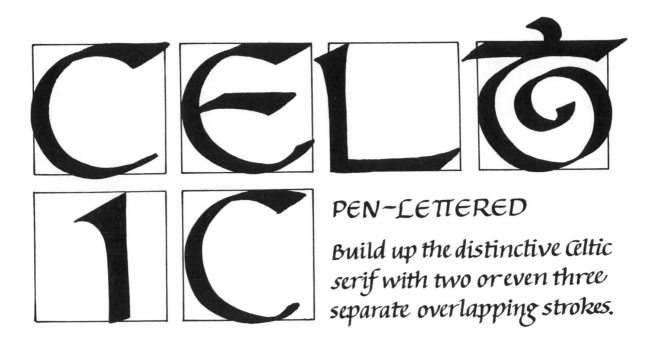

PEN-LETTERED

Build up the distinctive Celtic serif with two or even three separate overlapping strokes.

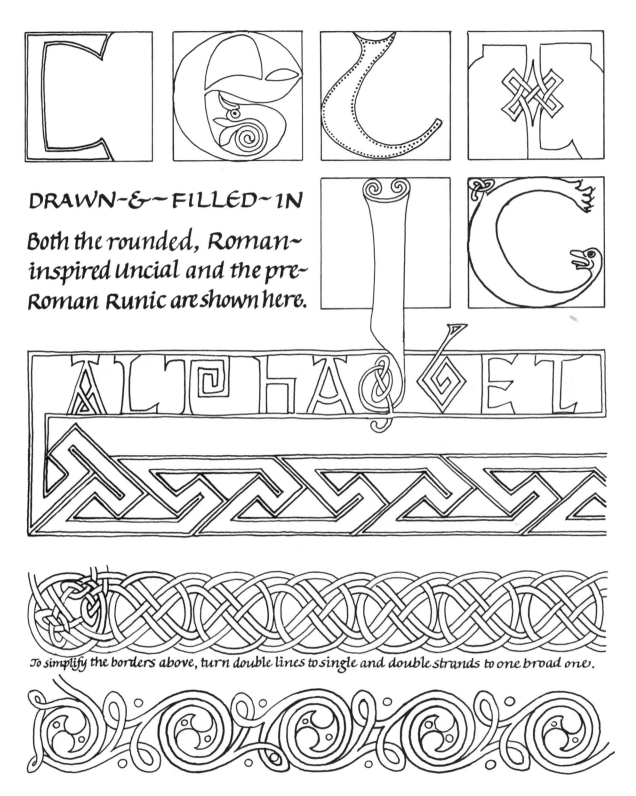

DRAWN~&~FILLED~IN

Both the rounded, Roman~ inspired Uncial and the pre~ Roman Runic are shown here.

To simplify the borders above, turn double lines to single and double strands to one broad one.

Note the accurate 'weaving' of Celtic borders; every UNDER is followed by an OVER.

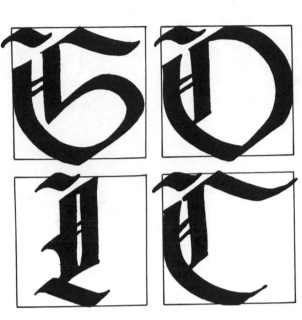
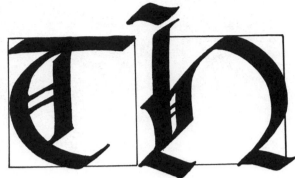

PEN~LETTERED

Gothic capitals are shown here enlarged for detail and below actual size for review.

THE GOTHIC

ABCDEFGHIJKLMNOPQRSTUVWXYZ

Gothic borders rely heavily on combinations of squares.

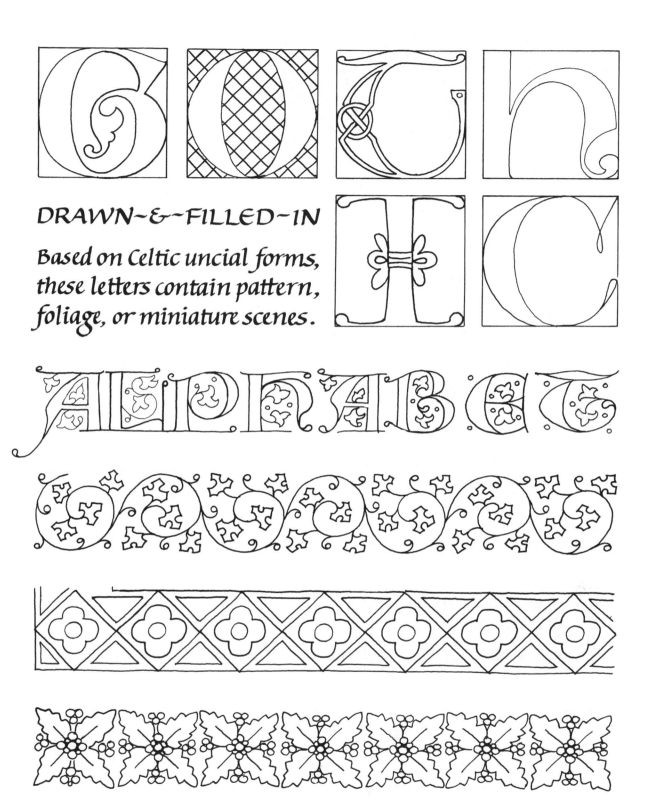

DRAWN~&~FILLED~IN

Based on Celtic uncial forms, these letters contain pattern, foliage, or miniature scenes.

BOOK

PEN-LETTERED

Bookhand generally uses Roman capitals for initials. They can be somewhat freer than the formal models. Just make sure that the proportions, weight, and serifs are similar.

the bookha

Note how Bookhand borders are a softer, more casual rendering of the angular Gothic designs.

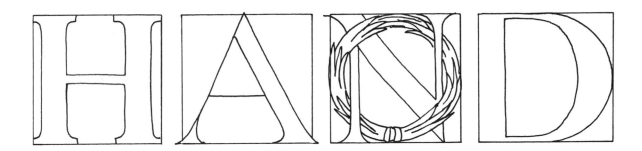

DRAWN~&~FILLED~IN

Based on classical Roman capitals, but drawn with compass and straightedge, these initials incorporate foliage and simple ornament. Keep the effect light and precise.

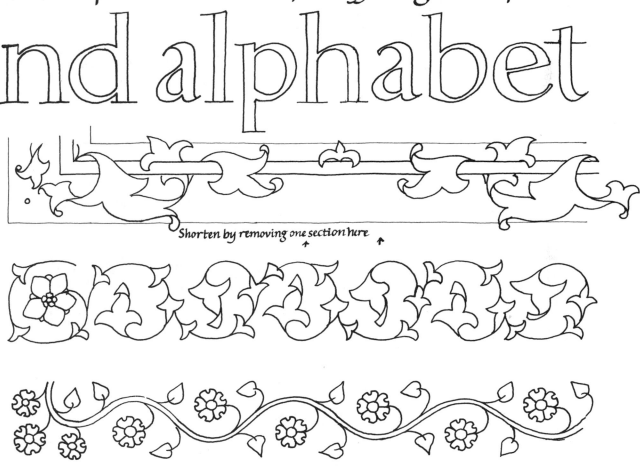

Shorten by removing one section here

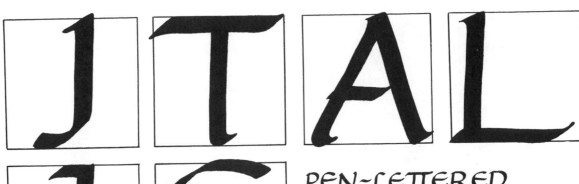

ITALIC

PEN-LETTERED

Italic capitals resemble a slanted version of Roman. Keep them simple at first.

THE ITALIC

ABCDEFGHIJKLMNOPQRSTUVWXYZ

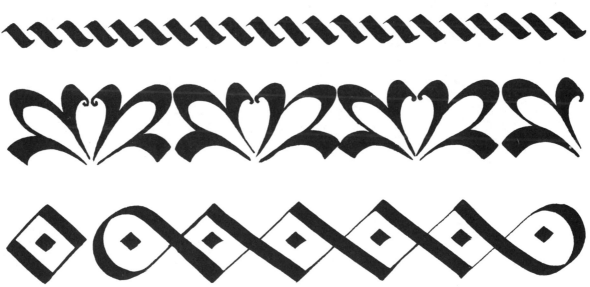

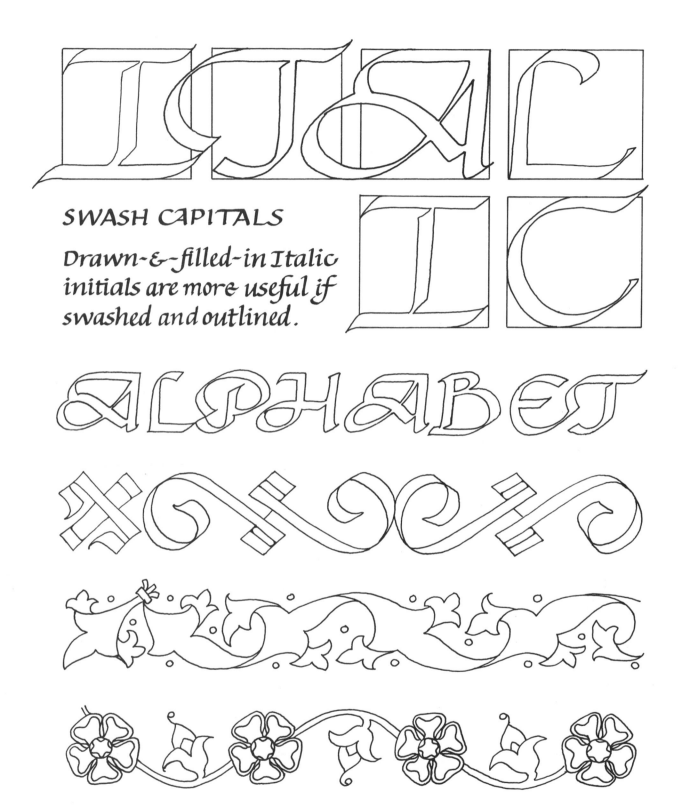

SWASH CAPITALS

Drawn-&-filled-in Italic initials are more useful if swashed and outlined.

Color Illumi- V nates Style

Do not bother to be quick.
The public will not ask
whether you have completed
your work in three days
but whether it is beautiful.

SEBASTIANO CONCA

COLOR ILLUMINATES STYLE

To illuminate your capitals and borders you need to study two aspects of color—which color to apply and how to handle it. The simplest and most pleasurable way to learn these VISUAL PRINCIPLES and TECHNICAL SKILLS is to re-enact the historical stages of their development.* By familiarizing yourself with the techniques of traditional illumination you will grasp the foundations of many visual customs; at the same time, your appreciation of the effect the artist was striving for will lead you to the correct technique. Your hand will teach your eye.

Try to think yourself back to the world of the artists whose craft you are trying to emulate. What were their lives like? Were they shivering or sweltering, optimistic or resigned, rushed or leisurely? What could they see out the window of their workroom? Were manuscripts considered artistic treasures, religious icons, or tools of the practical world? Were scribes and illuminators assured of a secure living or worried about bills? For whom were the manuscripts intended—readers or viewers? Which materials were plentiful and which were precious? Which other craft traditions were important to the society? And finally, what was the light like? Under what kind of light did the illuminator work and the viewer read? Was light sought or avoided? Did it soften or sharpen images?

*"Ontology recapitulates phylogeny." The growth of the individual repeats the growth of the species.

To cultivate this empathy with your calligraphic ancestors, look and read. Full-color reproductions of major manuscripts abound in facsimile editions and books about calligraphy. Museum stores offer cards, prints, books, and slides of manuscripts in their collections. Antique shops or antiquarian book dealers sometimes carry authentic pages from medieval books. Search also for parallel coloring in paintings, tapestries, architectural details, pottery, jewelry, and stained glass. Try to infer what influenced the artists' choice of color in different historical periods.

Read about illumination in medieval, Renaissance, and Victorian artists' manuals. Evaluate the materials in light of recent innovations and limitations. Bear in mind that the materials suggested in the following lessons are chosen not necessarily for historical accuracy * but because they are readily available, high quality, relatively inexpensive, versatile, and easy to handle. The emphasis is on acquiring a minimum of materials and then learning to apply them with intelligence, creativity, and care.

These five lessons will teach you the fundamentals of traditional illumination as applied to the capitals and borders of five pieces of calligraphy from the major historical styles. When you have completed your apprenticeship, branch out — not just to more elaboration, but to innovative colors, materials, and techniques. Your illumination should reflect the light of your twentieth-century world.

★ One recipe for red paint starts, "Take some ashes, sift them through a cloth, pour a little water over them, and make small rolls out of them like loaves of bread..." (Theophilus, On Divers Arts). Not for everyone.

ROMAN
WHITE & BLACK

palette

permanent
white

india
ink

Separate rinse water for black
and white

Winsor & Newton # 2 brush

Soft absorbent cloth or tissue

letters and ornament evolved from carved inscriptions and architectural borders. These forms are intended to be seen outside, in bright sunlight. Their 'colors' come from the gray stone background, black shadows, and white highlights. Reproducing these tones of gray can e-voke the three-demensional quality of authentic Roman carvings.

To highlight and shade the Roman capitals in the quotation on page 63 (the gray background is already provided to save you the labor of filling it in), assemble all the materials shown at left. Lay your book flat so that the ink and paint don't collect in a wet puddle at the bottom of the letter. Lift the dropper-stopper out of the India ink bottle with your left hand ✱ and carefully touch the side of the brush to it to fill the brush. Don't perform this operation over your lap unless you are wearing black. Now look at the letter outlines as though they were carved out of the surrounding flat gray stone and the light were shining on them from the left and above. Darken all the

✱ Right hand, if you are left-handed.

Light source

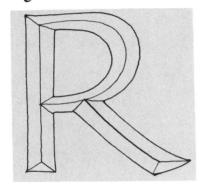

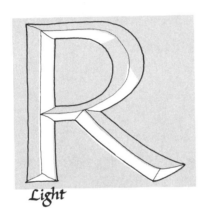

Light

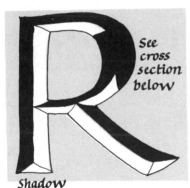

See cross section below

Shadow

Light source

Cross section

sections that would be in shadow. *
Shading diagonal strokes will be simpler
if you envision the light as originating
more from above than from the side.
Trade black & white in middle of curves.
Next, rinse your brush out thoroughly.
Squeeze a small amount of white into
the palette. Add a little water from
the clean rinse water and mix to the
consistency of thick cream (using an
older or cheaper brush for mixing will
save your good brush). Apply white
highlights to those letter and border
surfaces that would catch the light.
Since you are trying to achieve a carved
effect, cover up the black outlines wher-
ever you can.

A few suggestions may help you to
avoid some common problems. Keep
your brush clean and your rinse water
separate. Make sure each 'color' is dry
before you lay down another color next
to it.

If you are shading black-outlined fig-
ures on a white background, use only
gray and paint only shadows.

* An arbitrary tradition; but if you alter it your letter may appear <u>raised</u> instead of <u>carved</u>.

BOOKS
THINK
FOR·ME

CHARLES LAMB

CELTIC COLOR

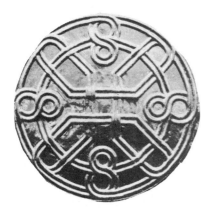

palette

Prussian blue

Rinse water

Winsor & Newton #2 brush

Soft absorbent cloth or tissue

letters and ornament grew from the strong crafts traditions of weaving, pottery, metalworking, and enamel~ling. The coils and spirals of Celtic borders echo the delicate filaments and dots of gold that decorate many ceremonial objects. Densely patterned over~and~under panels follow the physical limitations of woven patterns. Contrasting vividly with the soft and misty gray air of Ireland, the bright interlocked hues of Celtic borders re~call the glossy colors of fired enamels. And the stylized depiction of human and animal forms, the exaggeratedly bold black outlines, and the rich geo~metric mazes, all show the imported influence of Byzantine art.

Add color to the Celtic capital and bor~ders on page 67 by filling in the back~ground with solid blue ★ watercolor. Assemble the materials shown at left and squeeze a small amount of paint into the palette. Mix a little water with it, and brush it on smoothly.

★ You can use another color—green, perhaps—for this lesson if you wish, but you will still need the blue later.

incorrect

Correct

Dots with guideline

Guideline erased

Do not cover the black outlines, as they contribute to the authentic Celtic look. Fill in the border background as well. Now decorate the small capital with a row of dots. Draw light pencil guidelines if you find it too hard to keep the rows straight, and erase them when the dots are dry. You can also decorate the foreground of the border this way.

You may encounter a little awkwardness at first with these two techniques. You need a fuller brush to make fat, round dots than you do to make clearly outlined, flat backgrounds. Don't be surprised if you need some practice to get the results you want. Extra effort at this point to achieve control will help provide a firm foundation for building more skills later. Undue impatience will leave your illumination looking always a little ragged.

If you want to take the trouble to make your flat color brighter, smoother, and more permanent —more enamel-like— try diluting your color with egg yolk in place of water. (The yellow will disappear in mixing.)

Fear knocked
at the door

Faith answered

There was
no one there.

Sign over an old inn · Bray, England

Gothic Gold Leaf ❖

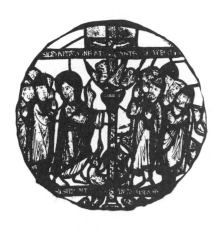

Winsor & Newton Illuminating Raising Preparation

Winsor & Newton #2 brush

small square of silk velvet drawn around cotton ball foundation, for handling pieces of gold leaf

Booklet of 25 gold leaves

Very sharp scissors, kept for gold leaf ONLY

Burnisher of agate, dog tooth or hematite

Tweezers

letters and ornament reflect the high medieval environment of superb architecture, music, tapestry, and stained glass. Life in the cold interior spaces of Northern Europe demanded arts that could create their own warmth and light through rich texture, vivid if naive realism, bright colors, and shining gold. A manuscript commissioned by a wealthy patron or the church might pass through the hands of a calligrapher to copy out the text, a rubricator to add the commentary, an illuminator to paint the border ornament, a miniaturist to detail the historiated capitals, a binder to make the parchment leaves into a bound volume, and a gold- or silversmith to stamp, clasp, and bejewel the finished book. Because the illuminated manuscript still has great visual appeal, a modern calligrapher can learn useful technique from its many component skills.

Add gold to your capital letter before you add color, to prevent the gold leaf from sticking to the pigment. Assemble the special gilding materials at left.

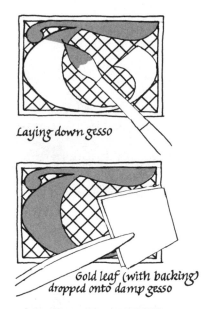

Laying down gesso

Gold leaf (with backing)
dropped onto damp gesso

Matte gold adhered to gesso

Matte gold burnished to shine

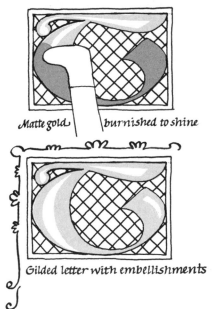

Gilded letter with embellishments

Dip out a little of the gesso and mix it with water to the consistency of thin cream. Paint the letter with the gesso. While it is still damp but not wet,* lean over it and breathe softly on it to moisten it. Lay a small piece of gold leaf & paper over it and press gently. Put it aside to dry.* Now burnish it, both to fasten the gold leaf more firmly to the gesso and to smoothe them both to a gleaming surface.**

Volumes*** have been written about the subtleties of this gilding process. Watch for the most common problems: laying the gesso on too thick, putting the gold on it too dry, and burnishing it too wet.

If you're patient and ambitious, gild all the vine leaves. If not, paint them blue, along with alternate squares of the capital background. For further embellishment, add tendrils of black or some color, with a very small pen, around the capital.

* Both these intervals depend on the weather, and can vary from a few minutes to a few days.
** To ensure solid coverage, breathe and add another layer of gold.
*** Two excellent sources are the chapters on gilding in Writing and Illuminating and Lettering by Edward Johnston, and The Calligrapher's Handbook edited by C.M. Lamb.

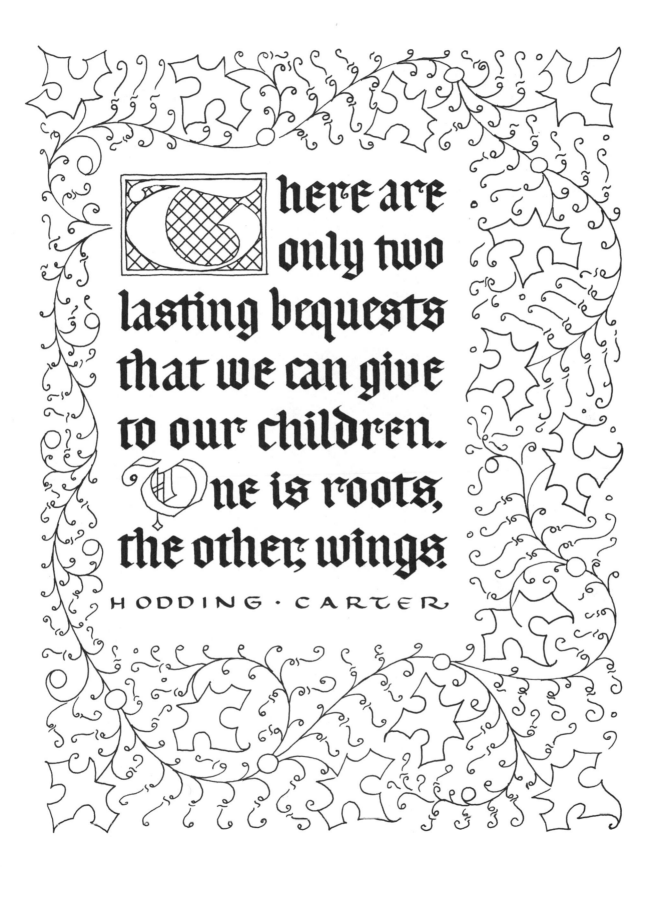

There are only two lasting bequests that we can give to our children. One is roots, the other, wings.

HODDING · CARTER

Bookhand

Color in tints

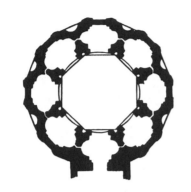

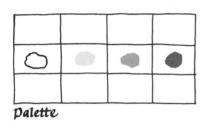

Palette

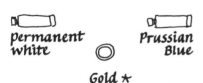

permanent
white

Prussian
Blue

Gold ★

Separate rinse water for blue,
white, and gold paint

Winsor & Newton #2 brush

Soft absorbent cloth or tissue

★ Gold paint may be substituted
for the gilding in the Gothic lesson
if gold leaf is too expensive.

letters and ornament flourished in the flat Italian sunlight of the Renaissance. The soft, weathered colors of terra cotta roofs and painted plaster walls provide a muted background for graceful frescoes, elegant costumes, and architecture of refined proportions. Humanistic manuscript colors seem gentle and harmonious, while the spectacle of shiny gold leaf is supplanted by the restrained gleam of powdered gold paint.

To evoke this mellow and elegant style, simply soften the strong color you have already been working with. Squeeze out a small amount of blue and mix to a spreading consistency. RINSE YOUR BRUSH WELL. Squeeze out three separate amounts of white and dilute to the same thickness. Now, using another brush if you have it, add a little blue to one white patch to make a pale tint of light blue. Add a little more blue to the other white patch to make a medium tint of blue. Reserve the remaining patch of white for highlights. Your palette of tints should look like the one

White Pale Medium Plain
 Blue Blue Blue

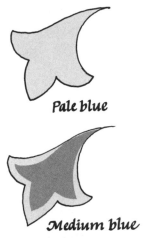

Pale blue

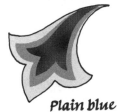

Medium blue

Plain blue

White

shown here at left.

Paint a two-toned capital, laying down the lighter shade first. Unite these two tints with a simple white overlay of foliage. Illuminate the border with the same approach. Fill each leaf with pale blue. Let dry. Paint the medium blue tint over this, leaving about one-third of the pale blue showing around the leaf's edge. For a subtle accent, put a row of pure white dots along the spine of the leaf.

Add gold to this capital and border by using gold paint. (Cover up harsh black outlines whenever you can.) To add texture to flat areas, blind~emboss a shiny filigree design onto the flat gold with a stylus, dry ballpoint, or pointed burnisher. Emphasize your scattered border dots of gold paint with burnished centers.

For further embellishment, make tints of another color and paint the leaves in more than just blue. Beware of blunting the effect with too many colors. Keep your color scheme monochrome; use extra colors mainly for accent.

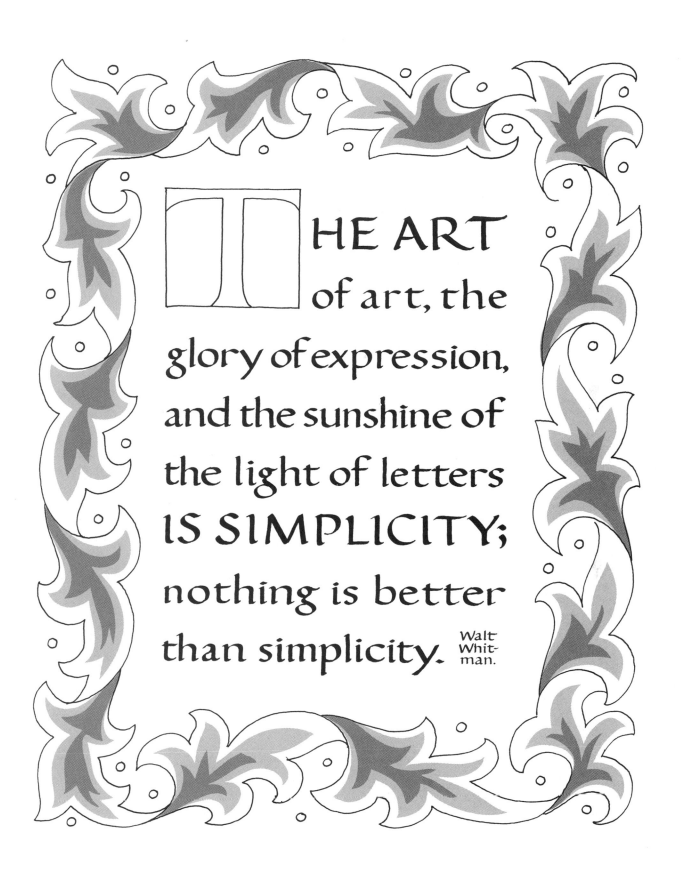

THE ART of art, the glory of expression, and the sunshine of the light of letters IS SIMPLICITY; nothing is better than simplicity. Walt Whitman.

Italic

Letters as ornament

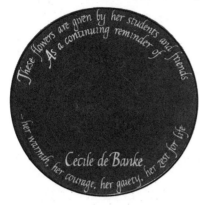

These flowers are given by her students and friends As a continuing reminder of her warmth, her courage, her gaiety, her zest for life

Cécile de Banke

palette

Two related hues of
water color, such as
Prussian blue and
green

Two hues of water-
color ink

Gold paint

Rinse water

Winsor & Newton #2 brush

Soft absorbent cloth or tissue

letters and ornament span five centuries and two continents. Born just before the advent of the printing press spelled the doom of the illuminated manuscript book, the Italic style languished unused for four hundred years until recently renewed interest gave it a fresh start. In many ways, Italic is a child of the twentieth century's approach to the layout of the written page — uncluttered design, generous allowance of white space, sparing but bold use of color, and an innovative sensitivity to the innate decorative qualities of the letter forms themselves.

To add ornamentation to letters that are essentially their own ornament, concentrate on how to color the letters themselves. First, put colored ink into your dip or fountain pen & write with that. Add a small capital or emphasize an important line of text. Do not work over pencilled letters; sometimes the ink may make them impossible to erase. And erasing will smear some ink in some weather.

You may find one limitation to this

a *a*

a *a*

To get colors
to divide at
the same
height in a
row of letters,
draw a pen-
cil line
but don't let
it actually go
across the letter.
Blend shades by
overlapping inks.

★ *Always start with the darker*
color and put it at the bottom, so
that the top of the letter can ap-
pear to "catch the light."

technique. The transparent colored ink is not as legible as India ink, and looks fainter on the page next to the strong, clear black. To offset this visual effect, first letter with a double-pointed outline pen; then fill in the space between the two lines with ink or watercolor to make the letter solid.

For larger letters, outline with two pencils taped together. Ink these pencil lines with a fine point. Then fill the empty letters with color.

A further refinement, which opens up a huge range of subtle experiments with color, involves shading a row of letters with not one but two colors. Draw a very light pencil line two thirds of the way up the letter bodies and fill with a color ★ at the bottom. Fill the tops with a second color or gold paint. Try filling in large and swashed letters with more than two colors.

If you still have the urge to add orna~ ment to Italic letters, try a light and simple floral swash that will echo the curved shape of the letters rather than the straight edges of the page.

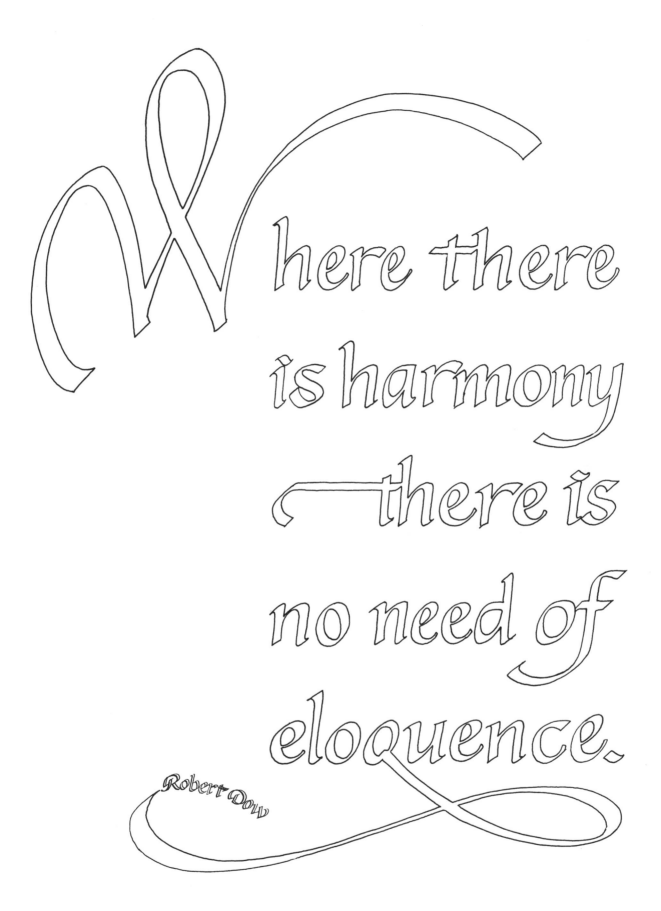

Where there is harmony there is no need of eloquence.

Robert Dow

Colors in painting
are as allurements
for persuading the eyes,
as the sweetness of meter
is in poetry.

NICOLAS POUSSIN

BORDERS TO ILLUMINATE

The borders that make up this chapter represent the merest sampling of the thousands of manuscript border designs available to the calligrapher today. These will just save you research & drawing time.

You can use these black-and-white borders in many ways: as frames for one-of-a-kind favorite quotations, displays, or honorary presentations. They reproduce well in photo-offset or Xerox copier if you use them as original artwork for flyers, invitations, or diplomas. You can add individual touches to them, such as, for instance, filling in the heraldic shield at the top of the twelfth border.

These borders are derived from a wide variety of sources to represent important historical periods. They have been carefully adapted to reproduce clearly, and simplified to facilitate coloring in various media. To illuminate them with the proper colors & techniques of traditional painting, review the five short color lessons in Chapter Five and choose the ones that apply to your border. Or try using your own accustomed media: oil paints, acrylics, pastels, colored pencils, felt pens.

One of the most instructive experiments you can do with these borders is to illuminate three or four copies of the same border with

different color schemes (trace or Xerox duplicates so you don't use up the one original). Paint two extremely different color schemes to see the wide range of expression available to you; paint two closely similar color schemes to see how small a change can still have effect.

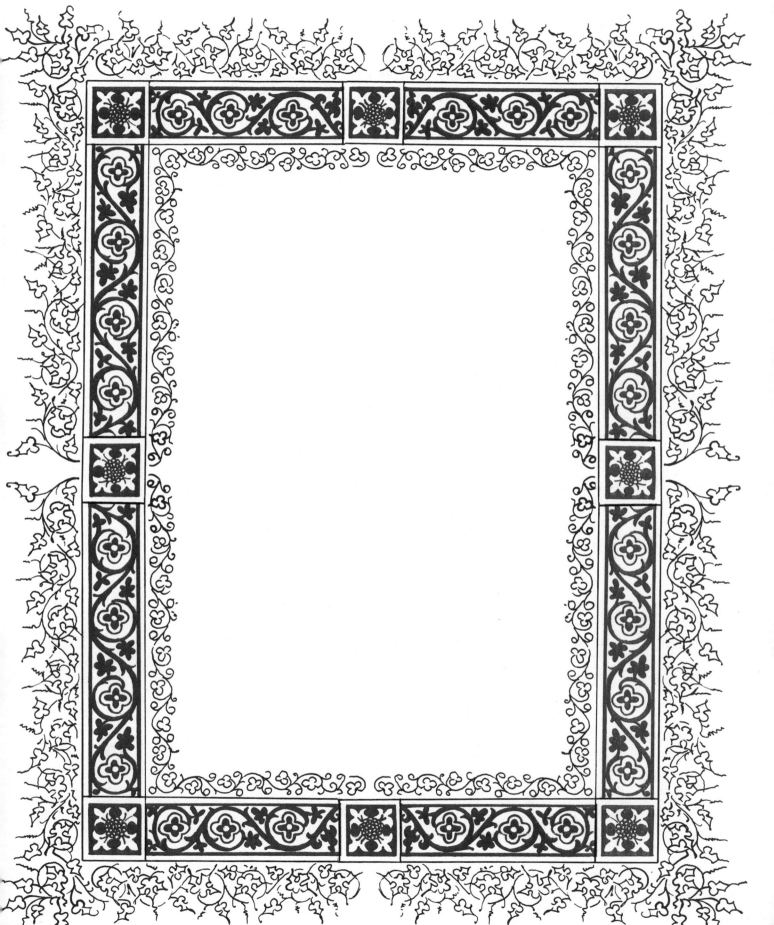

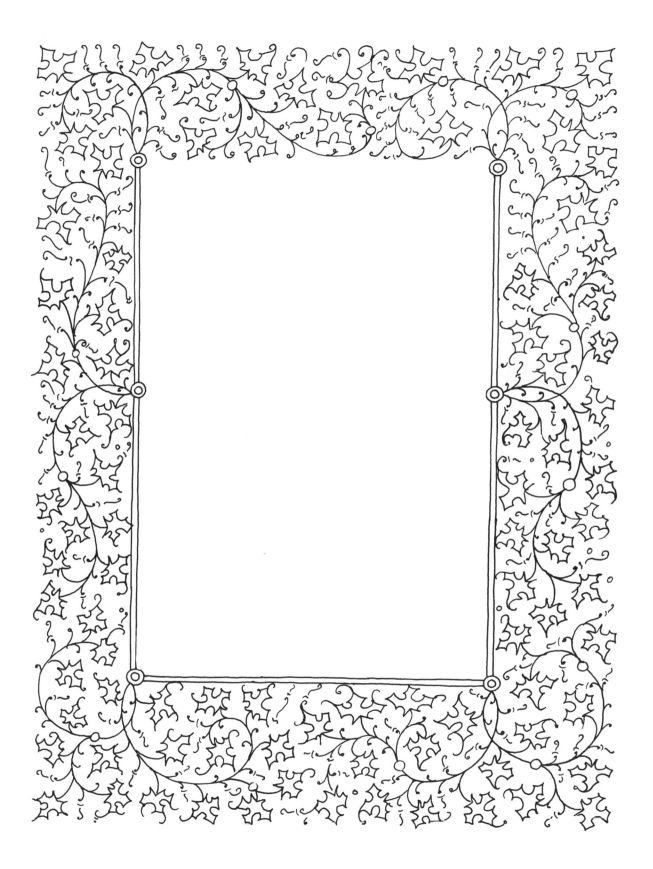

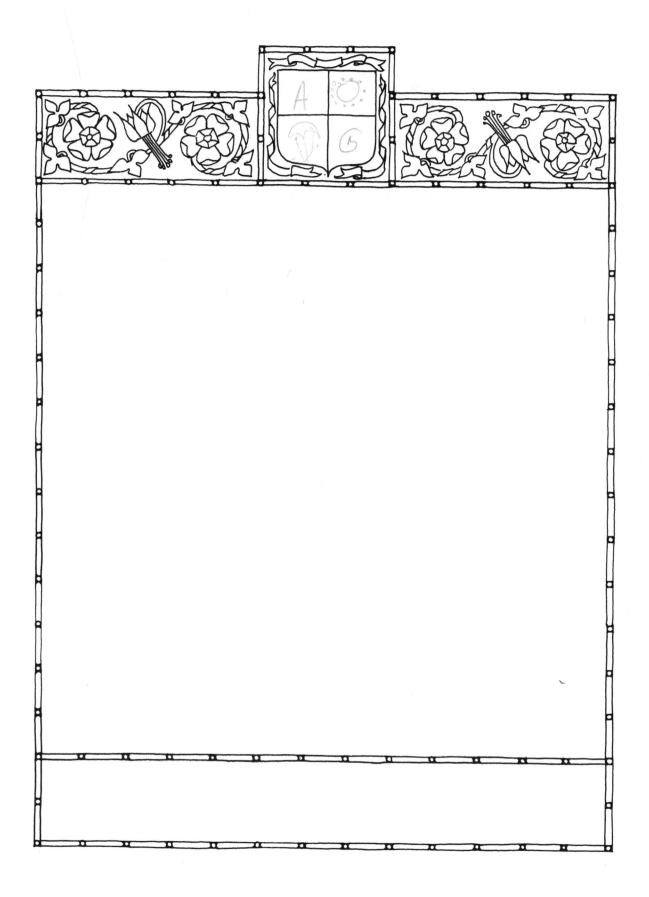

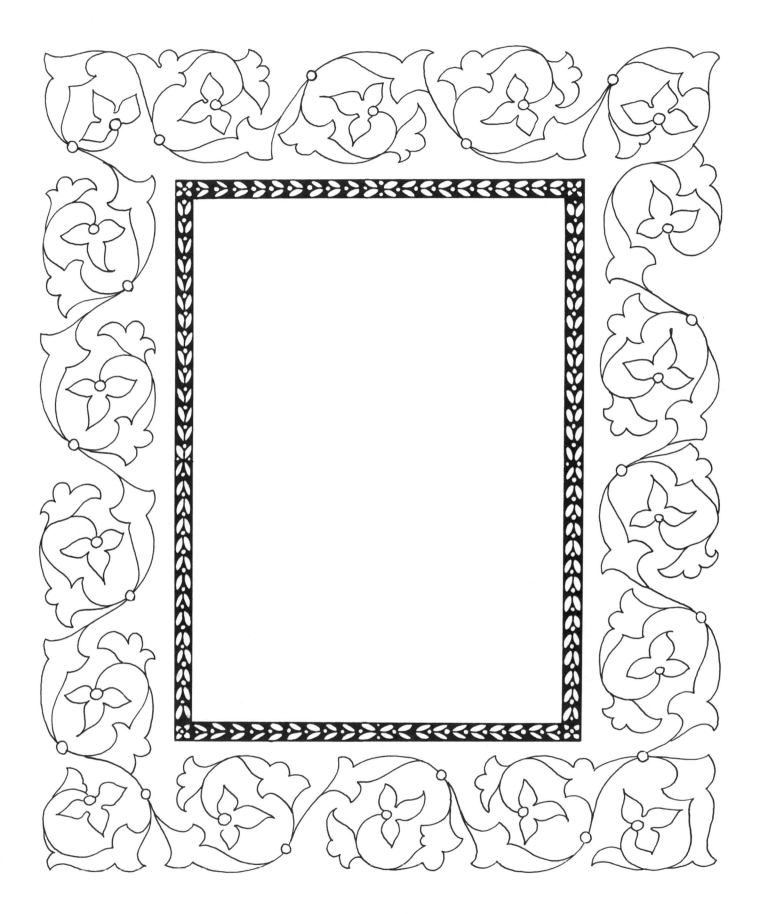

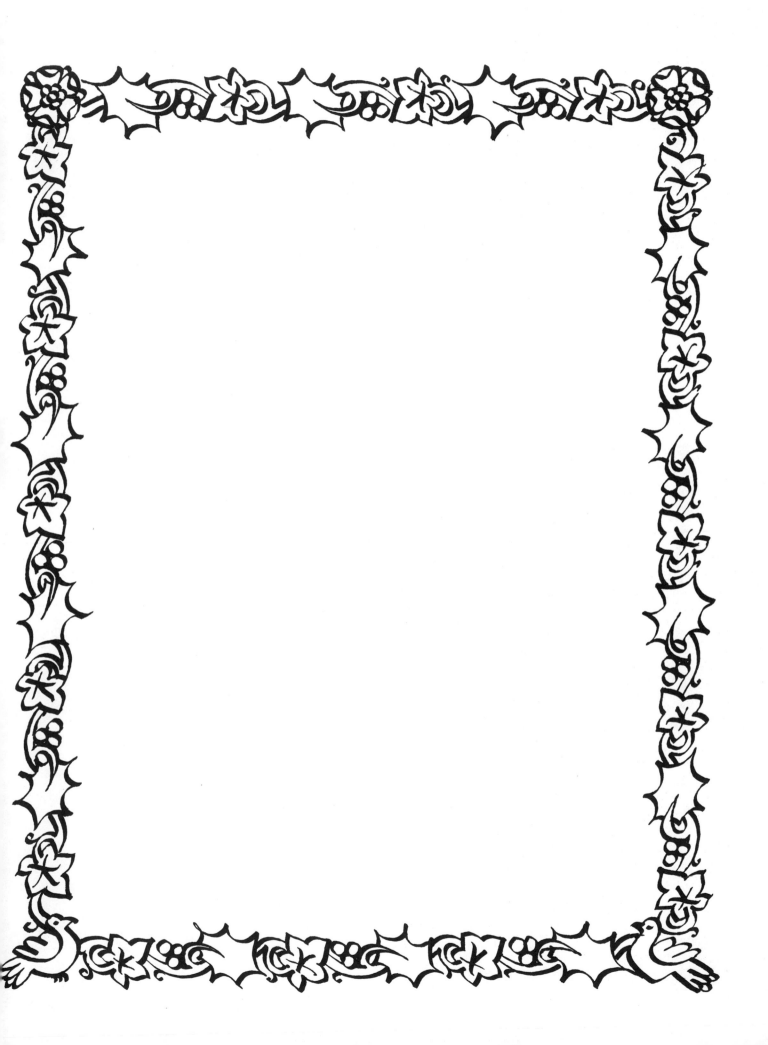

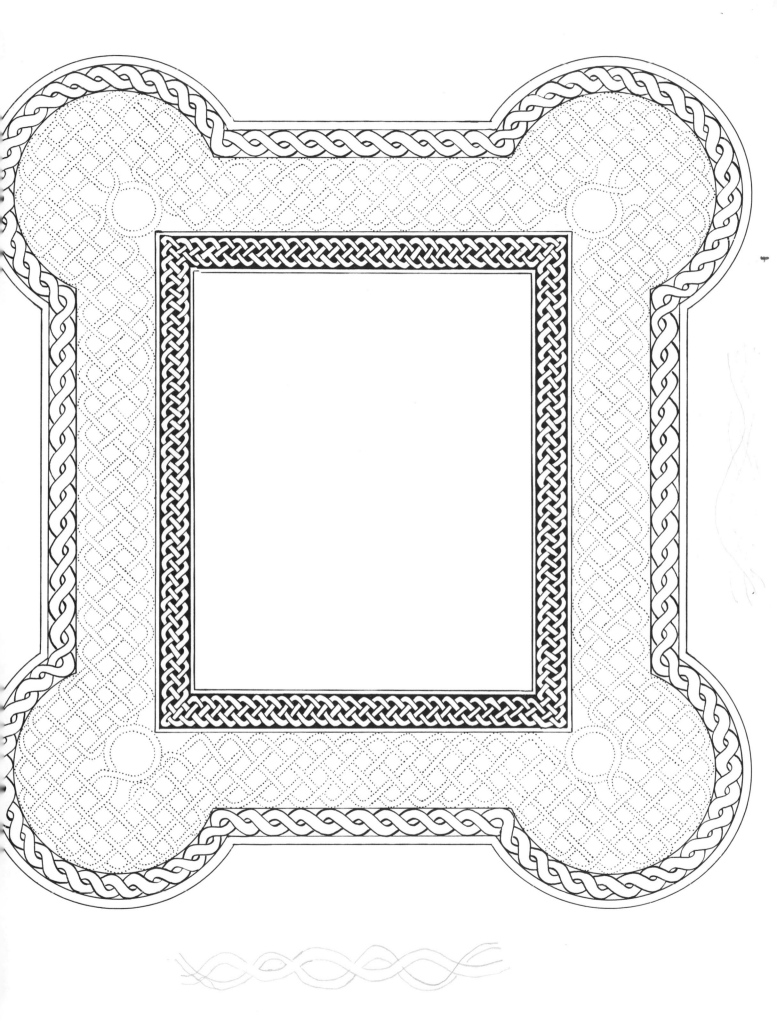

Special Techniques VII and Design Ideas

The painter must so paint each of his works
that it will look well designed,
judiciously composed, gracefully colored,
and be such as will incite
to devout feelings if it is sacred,
and to noble thoughts if it is not.
Thus he will please the painters with the design,
the learned with the composition,
the simple with the colors,
the religious with the devoutness,
and men of honor with the magnanimity.

ANDREA SACCHI

SPECIAL TECHNIQUES & DESIGN IDEAS

To keep ink or paint from running to the bottom of a letter or ornament, *lay your work down on a level surface.*

To make a repeating border even, and to save time in outlining, *draw one unit of the 'repeat' on stiff paper and move it along behind border guidelines on a light table.*

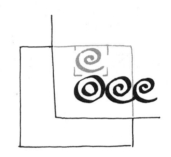

To give a border unity of coloring, *finish all items of one color before going on to the next color. Try to color your work so that you could stop after any stage and it would look balanced.*

After ten minutes' work, your border should look like this, rather than this.

To protect yourself from Titivillus (patron devil of scribes, who makes them ruin large works with small errors) *finish your lettering * before you work on the border. It's easier to hide errors in the border.* * Exception to this rule is on page 83.

The Society of Scribes & Illuminators
43 Earlham St., London WC2, England

To find out where your nearest calligraphers' organization is in the United States, subscribe to one or both of these two groups' newsletters. They publish periodic lists of the growing ranks of such organizations.

The Society of Scribes
Box 933, New York, N.Y., 10022

To make a bound book of lightweight paper and avoid show~through, letter on one side only and bind without slitting apart the pages. This also allows you the option of framing the pieces in the future.

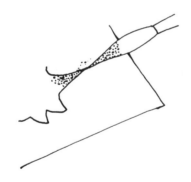

To paint really sharp corners, even with a fairly large brush, paint into the corner as you lift up. You will get a thinner line at the end of a brush stroke lifting up than at the beginning putting down.

ght and lengthen
| or center shorten
do a rough lengthen
en cut the lengthen
r into lengthen
aste and copy. shorten

To justify (make both right and left margins straight) or center a paragraph of text, first do a rough draft on practice paper. Then cut the text into strips for centering, or into words for justifying. Paste and copy.

To keep your illuminated colors bright, think beforehand about what kind of light will fall on them. For a framed piece in a sunny location, mix powdered pigments with egg yolk. For a framed piece in indirect sun or artificial light, use watercolor or gouache. In either case, delicate or unusual colors—particularly some of the ink dyes—may become "fugitive" (likely to fade) under prolonged exposure to light. Save these purples and deep blues for bound book pages that will be opened only occasionally.

To ink a line with a straightedge, prepare your ruler or triangle with a slight elevation above the paper by attaching two or three strips of masking tape to the back about $1/16$" from the edge.

To improvise a soft eraser for pencil marks and smudges, wad up a crustless piece of fresh white bread and rub it over your work. This technique has been used by scribes for centuries.

To add appealing—though not necessarily authentic—embellishments to your designs, try one or several of the next seven techniques.

Tear rather than cut the edges of your paper to give it an uneven "deckle" edge. Use edge of table or tear carefully after folding, not creasing.

uire

Add pale gray shadows to large letters to make them stand out from the surface of the page. Remember that the light usually comes from the left and above.

of Philosoph

With a crowquill or technical fountain pen touch up important headings, titles and names, to sharpen and embellish them.

B

Paint capitals in two slightly different shades of the same color to simulate the raised appearance of burnished gold.

Tiny dots of gold paint, burnished with a single touch of a pointed tool, can enrich margin spaces without distracting the eye.

Monogrammed seals and colored ribbons can finish off an honorary presentation with a medieval flourish. Improvise an "official" scribe's seal, by pressing a design of dots onto a foil decal (a standard item at stationery stores). Work in reverse on the back over soft blotting paper, using a very blunt pencil to give an embossed effect. If you want to use sealing wax and a monogrammed "signet" stamp, practice several times on plain paper before attempting the maneuver over a finished manuscript. The hot wax cools much faster than you expect!

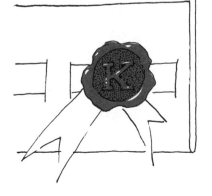

Choose satin or grosgrain ribbon in colors that harmonize with the illumination and seal. To be really authentic, lace the ribbon through slits in the lower margin and fasten with sealing wax. This used to prevent unauthorized additions to documents. Or you can just attach two short pieces of ribbon with the seal. Cut the ends at a slant to give a more interesting effect and to help prevent unraveling.

To keep a favorite calligraphy felt pen sharp, or to make one out of a regular felt marker, trim to a flat, chisel-tipped shape with a razor or x-acto blade on a pad of paper.

To add soft, intermediate tones of buff, beige, and gray to your illuminated manuscript pages, or to tone down a too-bright, unsubtle primary color, collect your rinse water and paint with it. You'll invent interesting, complex hues you couldn't come up with by mixing.

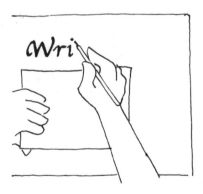

To protect your paper from the oils and moisture of your skin, always keep a piece of paper or large index card between your hand and your paper. This will also prevent your hand from smearing ink and paint. Light gloves with the fingers cut off are excellent for this purpose... and for warming stiff hands in a chilly scriptorium.

To get ideas for more borders, look around — at borders on clothing, furniture, jewelry, carpets, ironwork, glassware, book covers, advertisements, china, and buildings.